THE CULTURE-VULTURE'S
QUOTATION BOOK

The
Culture-Vulture's
Quotation Book

A Literary Companion

Edited by

SIMON PETHERICK

ROBERT HALE · LONDON

Preface and selection © Simon Petherick 1995
First published in Great Britain 1995

ISBN 0 7090 5616 8

Robert Hale Limited
Clerkenwell House
Clerkenwell Green
London EC1R 0HT

2 4 6 8 10 9 7 5 3 1

Photoset in Goudy by
Derek Doyle & Associates, Mold, Clwyd.
Printed and bound in Great Britain by
WBC Book Manufacturers Ltd.,
Bridgend, Mid-Glamorgan.

Preface

Let's get one thing straight: no self-respecting patron of the arts would ever call himself or herself a *culture-vulture*. An arts-lover, probably; an opera-goer, perhaps; but never *that* term!

Yet we all know a culture-vulture, don't we? He's the person who drags you to obscure first nights or difficult contemporary music evenings. She expects you to nod enthusiastically while she talks incomprehensibly about the latest nihilist painter to come out of an obscure province of the former Soviet Union.

For our culture-vulture friends, this volume is intended affectionately. It is, in one sense, full of the spirit that Matthew Arnold described as 'the acquainting ourselves with the best that has been known and said in the world'.

But it is also devoted to those who, after a

particularly long and demanding evening at a little-known venue, might sigh and agree with Auden that 'In the end art is small beer.'

Because the truth is that, as with most things, a little give and take is what is required – from both sides. Culture is what makes us: the question is, how much?

Acknowledgements

Acknowledgements are due to the following for permission to quote from material in copyright: *Tropic of Cancer* by Henry Miller, HarperCollins Publishers Ltd; *Psychology of the Unconscious* by Carl Gustav Jung, Routledge and Kegan Paul Ltd; *Understanding Media* by Marshall McCluhan, Routledge and Kegan Paul Ltd; *Zuleika Dobson* by Sir Max Beerbohm, Mrs Eva Reichmann; *The Black Prince* by Iris Murdoch, Chatto and Windus Ltd; *The Long Revolution* by Raymond Williams, Chatto and Windus Ltd. Every effort has been made to seek copyright permission, but any omissions will be remedied in future editions.

Mrs Ballinger is one of the ladies who pursue Culture in bands, as though it were dangerous to meet it alone.

EDITH WHARTON (1862–1937)
Xingu

'Music!' she said dreamily; and such is the force of habit that 'I don't,' she added, 'know anything about music, really. But I know what I like.'

SIR MAX BEERBOHM (1872–1956)
Zuleika Dobson
1911

Every man with a belly full of culture is an enemy of the human race.

HENRY MILLER (1891–1980)
Tropic of Cancer
1934

The public lies far outside consciousness of what is going on among artists. The public is both more stupid and purer, better at bottom perhaps.

SHERWOOD ANDERSON (1876–1941)
Letters
1953

Music and women I cannot but give way to, whatever my business is.

SAMUEL PEPYS (1633–1703)
Diary
9 March 1665

I am a Liberal, yet I am a Liberal tempered by experience, reflection, and renouncement, and I am, above all, a believer in culture.

> MATTHEW ARNOLD (1822–88)
> *Culture and Anarchy*
> 1869

You can only make art that talks to the masses when you have nothing to say to them.

> ANDRÉ MALRAUX (1901–76)
> *L'Espoir*
> 1938

Among all men on earth bards have a share of honour and reverence, because the muse has taught them songs and loves the race of bards.

> HOMER (*c.* 700 BC)
> *The Odyssey*

No furniture so charming as books.

> REVD SYDNEY SMITH (1771–1845)
> *Lady Holland's Memoir*
> 1855

You can lead a whore to culture but you can't make her think.

DOROTHY PARKER (1893–1967)
speech to American Horticultural Society

One should write not unskilfully in the running hand, be able to sing in a pleasing voice and keep good time to music; and, lastly, a man should not refuse a little wine when it is pressed upon him.

YOSHIDA KENKO (1283–1350)
Essays in Idleness

I don't think the artist should bother about his audience. His best audience is the person in his shaving mirror every morning. I think that the audience an artist imagines, when he imagines that kind of thing, is a room filled with people wearing his own mask.

VLADIMIR NABOKOV (1899–1977)
Strong Opinions
1974

Philistine Father: Why the dickens don't you paint something like Frith's *Derby Day* – something everybody can understand, and somebody buy?

Young genius: 'Everybody understand' indeed!
 Art is for the few, father, and the
 higher the art of course the fewer
 the few. The highest art of all is for
 one. That art is mine. That *one* is –
 myself.

Fond Mamma: There speaks my own brave boy!
 CARTOON IN *PUNCH*
 vol. 76, 249, 31 May 1879

Sir, I admit your gen'ral rule
That every poet is a fool;
But you yourself may serve to show it,
That every fool is not a poet.
 ALEXANDER POPE (1688–1744)
 Epigram from the French

Your true lover of literature is never fastidious.
 ROBERT SOUTHEY (1774–1843)
 The Doctor
 1812

For we are lovers of the beautiful without
extravagance, and cultivate our minds without
effeminacy.
 PERICLES (493–429 BC)
 Thucydides, ii.xl

It is native personality, and that alone, that endows a man to stand before presidents or generals, or in any distinguish'd collection, with aplomb – and not culture, or any knowledge or intellect whatever.

WALT WHITMAN (1819–92)
Democratic Vistas
1871

But Shakespeare one gets acquainted with without knowing how. It is part of an Englishman's constitution. His thoughts and beauties are so spread abroad that one touches them everywhere, one is intimate with him by instinct.

JANE AUSTEN (1775–1817)
Mansfield Park
1814

Our work is different; but it proceeds from the same source; each of us is a cultivator of a liberal art.

OVID (43 BC–AD 18)
Epistulae ex Ponto

Wagner has lovely moments, but awful quarters of an hour.

GIOCCHINO ROSSINI (1792–1868)
quoted in Emile Naumann's *Italienische Tondichter* (1883)

Nobody really sings in an opera – they just make loud noises.

> AMELITA GALLI-CURCI (1889–1963)
> Italian operatic soprano

A Society that sets up to be polite, and ignores Arts and Letters, I hold to be a Snobbish Society.

> WILLIAM MAKEPEACE THACKERAY (1811–63)
> *The Book of Snobs*
> 1846–7

French art, if not sanguinary, is usually obscene.

> HERBERT SPENCER (1820–1903)
> *Home Life with Herbert Spencer*
> 1906

Art is extra. If one was starving, one wouldn't do art. A sculptor's art is an expression of his religion.

> HENRY MOORE (1898–1986)
> quoted in *The Observer*, 1968

Shakespeare was the man who of all modern, and perhaps ancient poets, had the largest and most comprehensive soul.

> JOHN DRYDEN (1631–1700)
> *Essay of Dramatic Poesy*
> 1668

Literature and butterflies are the two sweetest passions known to man.

> VLADIMIR NABOKOV (1899–1977)
> quoted in *Radio Times*, October 1962

No poems can please for long or live that are written by water-drinkers.

> HORACE (68–5 BC)
> *Epistles*

'Painters and poets,' you say, 'have always had an equal license in bold invention.' We know; we claim the liberty for ourselves and in turn we give it to others.

> HORACE (68–5 BC)
> *Epistles*

Literature is an avenue to glory, ever open for those ingenious men who are deprived of honours or of wealth.

> ISAAC D'ISRAELI (1766–1848)
> *Literary Character of Men of Genius*

Life without industry is guilt, and industry without art is brutality.
> JOHN RUSKIN (1819–1900)
> *Lectures on Art*
> 1870

As a rule, high culture and military power go hand in hand, as evidenced in the cases of Greece and Rome.
> BRON KOLMAR VON DER GOLTZ (1843–1916)

The history of art is the history of revivals.
> SAMUEL BUTLER (1835–1902)
> *Note Books:* 'Handel and Music'

Those who love the arts are all fellow-citizens.
> VOLTAIRE (1694–1778)
> *Zaire, Dedication to Mr Falkener*

I have always suspected public taste to be a mongrel product, out of affectation by dogmatism.
> ROBERT LOUIS STEVENSON (1850–94)
> *Virginibus Puerisque*
> 1881

If it moves, the public will watch it.

> MARVIN KITMAN
> *You Can't Judge a Book by its Cover*
> 1970

The learned understand the theory of art, the unlearned its pleasure.

> QUINTILIAN (c. 35–95)

Fine art is that in which the hand, the head, and the heart go together.

> JOHN RUSKIN (1819–1900)
> *The Two Paths*
> 1859

The land of literature is a fairy land to those who view it at a distance, but, like all other landscapes, the charm fades on a nearer approach, and the thorns and briars become visible. The republic of letters is the most factious and discordant of all republics, ancient or modern.

> WASHINGTON IRVING (1783–1859)
> *Tales of a Traveller*

Culture, the acquainting ourselves with the best that has been known and said in the world, and thus with the history of the human spirit.

> MATTHEW ARNOLD (1822–88)
> *Literature and Dogma*
> 1873

Labour is the source of all wealth and all culture.

> FERDINAND LASSALLE (1825–64)
> *Arbeiter-Programm*
> 1862

The function of music is to release us from the tyranny of conscious thought.

> SIR THOMAS BEECHAM (1879–1961)
> *Beecham Stories*
> 1978

Culture saves nothing and nobody, nor does it justify. But it is a product of man: he projects himself through it and recognises himself in it; this critical mirror alone shows him his image.

> JEAN-PAUL SARTRE (1905–80)
> *Words*
> 1964

All books are divisible into two classes: the books of the hour, and the books of all time.
> JOHN RUSKIN (1819–1900)
> *Sesame and Lilies*
> 1865

It is life that shakes and rocks us; it is literature which stabilises and confirms.
> HEATHCOTE WILLIAMS GARROD
> *Profession of Poetry*

Horses and poets should be fed, not overfed.
> CHARLES IX of Sweden (1550–1611)
> attributed

Athens, the eye of Greece, mother of arts and eloquence.
> JOHN MILTON (1608–74)
> *Paradise Regained*
> 1671

France, fam'd in all great arts, in none supreme.
> MATTHEW ARNOLD (1822–88)
> *To A Republican Friend*

Architecture in general is frozen music.
> FRIEDRICH VON SCHELLING (1775–1854)
> *Philosophie der Kunst*

The human capacity for being bored, rather than man's social or natural needs, lies at the root of man's cultural advance.
> RALPH LINTON (1893–1953)
> *The Study of Man*
> 1936

What the public like best is fruit that is overripe.
> JEAN COCTEAU (1889–1963)
> in *The Faber Book of Aphorisms*, 1964

Nobody cares much at heart about Titian; only there is a strange undercurrent of everlasting murmur about his name, which means the deep consent of all great men that he is greater than they.
> JOHN RUSKIN (1819–1900)
> *The Two Paths*
> 1859

If Music and sweet Poetry agree,
As they must needs (the Sister and the Brother)
Then must the love be great, 'twixt thee and me,
Because thou lov'st the one, and I the other.
RICHARD BARNFIELD (1574–1627)
Poems: 'In Divers Humors'

Culture is not life in its entirety, but just the moment
of security, strength and clarity.
JOSÉ ORTEGA Y GASSET (1883–1955)
Meditations on Don Quixote
1914

All art is quite useless.
OSCAR WILDE (1854–1900)
The Picture of Dorian Gray
1890

A man becomes truly Man only when in quest of what
is most exalted in him. True arts and cultures relate
man, to duration, sometimes to eternity and make of
him something other than the most favoured denizen
of a universe founded on absurdity.
ANDRÉ MALRAUX (1901–76)
Voices of Silence
1953

Literature exists to please – to lighten the burden of men's lives; to make them for a short while forget their sorrows and their sins, their silenced hearths, their disappointed hopes, their grim futures – and those men of letters are best loved who have best performed literature's truest office.

AUGUSTINE BIRRELL (1850–1933)
Obiter Dicta
1884

A man of one idea – that all civilisation was the printed fungus of rottenness. He hated any sign of culture.

D.H. LAWRENCE (1885–1930)
The White Peacock
1911

The aesthetic sense ... is akin to the sexual instinct, and shares its barbarity.

W. SOMERSET MAUGHAM (1874–1965)
The Moon and Sixpence
1919

There are a hundred thousand men born to live and die who will not be as valuable to the world as one canvas.

> SHERWOOD ANDERSON (1876–1941)
> *Letters*
> 1953

Most wretched men
Are cradled into poetry by wrong:
They learn in suffering what they teach in song.
> PERCY BYSSHE SHELLEY (1792–1822)
> *Julian and Madallo*
> 1818

Give honour unto Luke Evangelist
For he it was (the aged legends say)
Who first taught Art to fold her hands and pray.
> DANTE GABRIEL ROSSETTI (1828–82)
> *Sonnets:* no. 74

I am tired of art galleries, cemeteries of the arts.
> LAMARTINE (1790–1869)
> *Voyage en Orient*
> 1835

Great Literature is simply language charged with meaning to the utmost possible degree.
 EZRA POUND (1885–1972)
 How to Read

Poets are the unacknowledged legislators of the world.
 PERCY BYSSHE SHELLEY (1792–1822)
 A Defence of Poetry
 1821

It may be taken as an axiom that the majority is always wrong in cultural matters ... Politically I believe in democracy, but culturally, not at all. Whenever a cultural matter rolls up a majority, I know it is wrong.
 JOHN SLOAN (1871–1951)
 in Van Wyck Brooks' *John Sloan*, 1955

I think of art, at its most significant, as ... a distant early warning system that can always be relied on to tell the old culture what is beginning to happen to it.
 MARSHALL McCLUHAN (1911–80)
 Understanding Media
 1964

I remember being handed a score composed by Mozart at the age of eleven. What could I say? I felt like de Kooning, who was asked to comment on a certain abstract painting, and answered in the negative. He was then told it was the work of a celebrity monkey. 'That's different. For a monkey, it's terrific.'

IGOR STRAVINSKY (1882–1971)
in *London Magazine*, March 1967

New arts destroy the old.
RALPH WALDO EMERSON (1803–82)
Essays: 'Circles'

Through all the shrines [at Stratford-on-Avon] surge English and American tourists, either people who have read too much Shakespeare at the expense of good, healthy detective stories or people who have never read him at all and hope to get the same results by bumping their heads on low beams. All of Stratford, in fact, suggest powdered history – add hot water and stir and you have a delicious, nourishing Shakespeare.

MARGARET HALSEY (1910–)
With Malice towards Some

Poetry is the record of the best and happiest moments of the happiest and best minds.

PERCY BYSSHE SHELLEY (1792–1822)
A Defence of Poetry
1821

I believe only in French culture, and regard everything else in Europe which calls itself 'culture' as a misunderstanding. I do not even take the German kind into consideration.

FRIEDRICH WILHELM NIETZSCHE (1844–1900)
Ecce Homo
1888

Words are the only things that last forever.

WILLIAM HAZLITT (1778–1830)
Table Talk: 'On Thought and Action'
1821–2

The problem with a film is that it has a beginning and an end. You can look at a painting for as long as you like.

ROBERT ALTMAN
quoted in *New York Herald Tribune*, 1972

The most immoral and disgraceful and dangerous thing that anybody can do in the arts is knowingly to feed back to the public its own ignorance and cheap tastes.

> EDMUND WILSON (1895–1972)
> *Memoirs of Hecate Country*
> 1946

No work of art is worth the bones of a Pomeranian Grenadier.

> OTTO VON BISMARCK (1815–98)
> speech to Prussian Upper House, 12 April 1886

Poets tell many lies.

> SOLON (638–559 BC)
> *Fragment*

The great law of culture is: Let each become all that he was created capable of being.

> THOMAS CARLYLE (1795–1881)
> *Richter*

For a good poet's made, as well as born.
> BEN JONSON (1572–1637)
> *To the Memory of My Beloved, the Author,*
> *Mr William Shakespeare*
> 1623

Culture would not be culture if it were not an acquired taste.
> JOHN COWPER POWYS (1872–1963)
> *The Meaning of Culture*

For Art stopped short in the cultivated court of the Empress Josephine.
> W.S. GILBERT (1836–1911)
> *Patience*
> 1881

Art, properly so called, is no recreation. It cannot be learned at spare moments, nor pursued when we have nothing better to do.
> JOHN RUSKIN (1819–1900)
> *Modern Painters*
> 1834–60

It surprises me how many ladies and gentlemen with broken hearts, howling into the microphone like amorous cats, the public will swallow.

> KENNETH, LORD CLARK (1903–83)
> on resigning as chairman of ITA, 1957

Art has something to do with the achievement of stillness in the midst of chaos.

> SAUL BELLOW (1915–)
> in *Writers at Work*, edited by George Plimpton

Art is the Tree of Life. Science is the Tree of Death.

> WILLIAM BLAKE (1757–1827)
> *Jah and His Two Sons, Satan and Adam*

Hang art, madam! and trust to nature for dissembling.

> WILLIAM CONGREVE (1670–1729)
> *The Old Batchelor*
> 1693

If one has no heart, one cannot write for the masses.

> HEINRICH HEINE (1797–1856)
> letter to Julius Campe, 1840

And what is culture but palaver and swank. I turn up my nose at culture.

> IDRIS DAVIES
> *The Lay Preacher Ponders*

Culture is 'to know the best that has been said and thought in the world'.

> MATTHEW ARNOLD (1822–88)
> *Literature and Dogma*
> 1873

Is there a heart that music cannot melt?
Alas! how is that rugged heart forlorn.

> JAMES BEATTIE (1735–1803)
> *The Minstrel*

Remember I'm an artist. And you know what that means in a court of law. Next worse to an actress.

> JOYCE CARY (1888–1957)
> *The Horse's Mouth*
> 1944

Culture is what your butcher would have if he were a surgeon.

> MARY PETTIBONE POOLE
> *A Glass Eye at the Keyhole*

Ah! What avails the classic bent
And what the cultured word,
Against the undoctored incident
That actually occurred?
RUDYARD KIPLING (1865–1936)
The Benefactors

Religion and art spring from the same root and are close kin. Economics and art are strangers.
WILLA CATHER (1875–1947)
On Writing

The soul takes nothing with her to the other world but her education and culture; and these, it is said, are of the greatest service or of the greatest injury to the dead man, at the very beginning of his journey thither.
PLATO (428–348 BC)
Dialogues: 'Phaedo'

'Fool!' said my muse to me, 'look in thy heart, and write.'
SIR PHILIP SIDNEY (1554–86)
Astrophel and Stella

I am convinced more and more every day that fine writing is, next to fine doing, the top thing in the world.

> JOHN KEATS (1795–1821)
> letter to J.H. Reynolds
> 1819

If they could forget for a moment the correggiosity of Correggio.

> THOMAS CARLYLE (1795–1881)
> *Frederick the Great*

What passion cannot Music raise and quell?

> JOHN DRYDEN (1631–1700)
> *A Song for St Cecilia's Day*
> 1687

We have on radio every Sunday a stroke of culture, a symphony concert from New York or somewhere with a tooth-wash. That's the culture part, the tooth-wash.
> LINCOLN STEFFENS
> *Autobiography*

Art and Religion are, then, two roads by which men escape from circumstance to ecstasy.
> CLIVE BELL (1881–1962)
> *Art*
> 1914

Pray consider what a figure a man would make in the republic of letters.
> JOSEPH ADDISON (1672–1719)
> *Ancient Medals*

Art is not necessary at all. All that is necessary to make this world a better place to live in is to love.
> ISADORA DUNCAN (1877–1927)
> in *This Quarter*
> Paris, 1929

A truly poetic canvas is an awakened dream.
> RENÉ MAGRITTE (1898–1967)
> *Letter*
> 1960

If you're anxious for to shine in the high aesthetic line
as a man of culture rare.
> W.S. GILBERT (1836–1911)
> *Patience*
> 1881

Art is one thing and morals quite another. The
contribution of the artist is not to be disparaged by the
recollection or arraignment of ethical frailty.
> FREDERICK EDWIN SMITH, EARL OF BIRKENHEAD
> (1872–1931)
> address to the Scottish Society, 1924

The arts babblative and scribblative.
> ROBERT SOUTHEY (1774–1843)
> *Colloquies on the Progress and Prospects of Society*

The envious man, the passionate, the idle, the drunken, the lewd, no one is so far unreclaimed that he cannot become civilised, if only he will lend a patient ear to culture.

> HORACE (68–5 BC)
> *Epilogues*

Art happens – no hovel is safe from it, no Prince may depend upon it, the vastest intelligence cannot bring it about.

> JAMES ABBOTT McNEILL WHISTLER (1834–1903)
> *Ten O'Clock Lecture*

Note too that a faithful study of the liberal arts humanises the character and permits it not to be cruel.

> OVID (43 BC–18 AD)
> *Epistulae ex Ponto*

An artist carries on through his life a mysterious, uninterrupted conversation with his public.

> MAURICE CHEVALIER
> *Holiday*
> 1956

Art is a collaboration between God and the artist, and the less the artist does the better.
ANDRÉ GIDE (1869–1951)

Music, the greatest good that mortals know,
And all of heaven we have below.
JOSEPH ADDISON (1672–1719)
A Song for St Cecilia's Day

Artists hate the enlightened amateur unless he buys.
ERNEST DIMNET
What We Live By

Sir Andrew: I would I had bestowed that time in the tongues that I have in fencing, dancing, and bear-baiting. O! had I but followed the arts!

Sir Toby: Then hadst thou had an excellent head of hair.
WILLIAM SHAKESPEARE (1564–1616)
Twelfth Night

In my youth people talked about Ruskin; now they talk about drains.

> MRS HUMPHREY WARD (1851–1920)
> *Robert Elsmere*
> 1888

I hate all Boets and Bainters.

> KING GEORGE I (1660–1727)
> in Campbell's *Lives of the Chief Justices*

Music alone with sudden charms can bind
The wand'ring sense, and calm the troubled mind.

> WILLIAM CONGREVE (1670–1729)
> *Hymn to Harmony*

Art for art's sake.

> VICTOR COUSIN (1792–1867)
> *Sorbonne Lectures*

All art deals with the absurd and aims at the simple. Good art speaks truth, indeed *is* truth, perhaps the only truth.

> IRIS MURDOCH (1919–)
> *The Black Prince*
> 1973

The works of art, by being publicly exhibited and offered for sale, are becoming articles of trade, following as such the unreasoning laws of markets and fashion; and public and even private patronage is swayed by their tyrannical influence.

> ALBERT, PRINCE CONSORT (1819–61)
> speech at the Royal Academy Dinner, 3 May 1851

'But how divine is utterance!' she said. 'As we to the brutes, poets are to us.'

> GEORGE MEREDITH (1828–1909)
> *Diana of the Crossways*
> 1885

Whenever I enjoy anything in art it means that it is mighty poor.

> MARK TWAIN (1835–1910)
> *Essays:* 'At the Shrine of St Wagner'

The difference between Art and Life is that Art is more bearable.

> CHARLES BUKOWSKI
> *Notes of a Dirty Old Man*
> 1969

But in Eternity the Four Arts, Poetry, Painting, Music, And Architecture, which is Science, are the Four Faces of Man.
WILLIAM BLAKE (1757–1827)
Milton
1804

Pictures deface walls oftener than they decorate them.
FRANK LLOYD WRIGHT (1869–1959)
quoted in *Saturday Evening Post*, 1961

The revolt against individualism naturally calls artists severely to account, because the artist is of all men the most individual: those who were not have been long forgotten. The condition every art requires is, not so much freedom from restriction, as freedom from adulteration and from the intrusion of foreign matter, considerations and purposes which have nothing to do with spontaneous invention.

WILLA CATHER (1875–1945)
On Writing

But as every art ought to be exercised in our subordination to the public good, I cannot but propose it as a moral question, whether they do not sometimes play too wantonly with our passions.

SAMUEL JOHNSON (1709–84)
Lives of the English Poets
1779–81

Statues and pictures and verse may be grand,
But they are not the life for which they stand.

JAMES THOMSON (1838–82)
Sunday Up The River

Music is the thing of the world that I love most.
SAMUEL PEPYS (1633–1703)
Diary
30 July 1666

A dance is a measured pace, as a verse is a measured speech.
FRANCIS BACON (1561–1626)
The Advancement of Learning
1605

Poesy was ever thought to have some participation of divineness, because it doth raise and erect the mind by submitting the shews of things to the desires of the mind.

FRANCIS BACON (1561–1626)
The Advancement of Learning
1605

When they talked of their Raphaels, Correggios
 and stuff,
He sniffed his trumpet and only took snuff.
OLIVER GOLDSMITH (1728–74)
Retaliation
1774

The assertion that art may be good art and at the same time incomprehensible to a great number of people, is extremely unjust; and its consequences are ruinous to art itself.

LEO TOLSTOY (1828–1910)
What is Art?
1898

Painting is silent poetry, and poetry painting that speaks.

SIMONIDES (556–468 BC)
from Plutarch's *De Gloria Atheniensium*

The psychology of the creative is really feminine psychology, a fact which proves that creative work grows out of the unconscious depths, indeed out of the region of the mothers.

> CARL GUSTAV JUNG (1875–1961)
> in the *Times Literary Supplement*, 6 August 1954

Philistinism means impatience with art.

> JOHN BERGER (1926–)
> in the *Daily Worker*, 1963

Engraving is, in brief terms, the art of scratch.

> JOHN RUSKIN (1819–1900)
> *Ariadne Fiorentina*
> 1873–6

Music is the poor man's Parnassus.

> RALPH WALDO EMERSON (1803–82)
> *Poetry and Imagination*

The great artists of the world are never Puritans, and seldom even ordinarily respectable.

> HENRY LOUIS MENCKEN (1880–1956)
> *Prejudices*, First Series
> 1919

Such Artists as Reynolds are at all times hired by the Satans for the depression of Art – A Pretence of Art, to destroy Art.

> WILLIAM BLAKE (1757–1827)
> *Reynold's Discourses*
> 1808

The poet is like the prince of clouds, who rides out the tempest and laughs at the archer. But when he is exiled on the ground, amidst the clamour, his giant's wings prevent him from walking.

> CHARLES BAUDELAIRE (1821–67)
> *L'Albatros*

The lower one's vitality, the more sensitive one is to great art.

> SIR MAX BEERBOHM (1872–1956)
> *Seven Men*
> 1919

Good native Taste, though rude, is seldom wrong,
Be it in music, painting, or in song:
But this, as well as other faculties,
Improves with age and ripens by degrees.

> JOHN ARMSTRONG (1709–79)
> *Taste*
> 1753

One of those queer artistic dives,
Where funny people had their fling.
Artists, and writers, and their wives –
Poets, all that sort of thing.
>OLIVER HERFORD
>*The Women of the Better Class*

Nor is it possible to devote oneself to culture and declare that one is 'not interested' in politics.
>THOMAS MANN (1875–1955)
>*Freedom*
>1940

Bellamy Brown (on a picture by Rigby Robinson):
 Quite a poem! Distinctly precious, blessed, subtile, significant, and supreme!
Jordan Jones (to whom a picture by Rigby Robinson is as a red rag to a bull, as Bellamy Brown knows):
 Why, hang it man, the drawing's vile, the colour beastly, the composition idiotic, and the subject absurd!
Bellamy Brown:
 Ah, *all* works of the *highest* genius have faults of that description!

Jordan Jones:

Have they? I'm glad to hear it, then, for there's a chance for *you*, old man.

CARTOON in *PUNCH*
vol. 77, 35, 26 July 1879

A play should give you something to think about. When I see a play and understand it the first time, then I know it can't be much good.

T.S. ELIOT (1888–1965)
quoted in *New York Post*, 1963

A musicologist is a man who can read music but can't hear it.

SIR THOMAS BEECHAM (1879–1961)
in H. Proctor-Gregg's *Beecham Remembered*

In the end art is small beer. The really serious things in life are earning one's living so as not to be a parasite and loving one's neighbour.

W.H. AUDEN (1907–73)
in *Esquire*, 1970

The great aim of culture is the aim of setting ourselves to ascertain what perfection is and to make it prevail.

MATTHEW ARNOLD (1822–88)
Culture and Anarchy
1869

Those who dwell in ivory towers
Have heads of the same material.

LEONARD BACON
Tower of Ivory

Any art which professes to be founded on the special education or refinement of a limited body or class must of necessity be unreal and short-lived. Art is man's expression of his joy in labour.

WILLIAM MORRIS (1834–96)
Art Under Plutocracy
1883

When art communicates, a human experience is actively offered and actively received. Below this activity threshold there can be no art.

> RAYMOND WILLIAMS (1921–)
> *The Long Revolution*
> 1961

The statue is beautiful when it begins to be incomprehensible.

> RALPH WALDO EMERSON (1803–82)
> *Essays:* 'Compensation'

When I hear anyone talk of Culture, I reach for my revolver.

> HERMANN GOERING (1893–1946)
> attributed

(Although the following appeared in *Schlageter* by the Nazi writer Hanns Johst in 1934: 'Wenn ich Kulture hore ... entsichere ich meinen Browning')

> There's a new tribunal now
> Higher than God's – the educated man's!
> ROBERT BROWNING (1812–89)
> *The Ring and the Book*
> 1868–9

Thus may I think the adopting Muses chose
Their sons by name, knowing none would be heard
Or writ so oft in all the world as those, –
Dan Chaucer, mighty Shakespeare, then for third
The classic Milton, and to us arose
Shelley with liquid music in the word.
> ROBERT BRIDGES (1844–1930)
> *The Growth of Love*

We can say nothing but what hath been said. Our poets steal from Homer ... Our story-dressers do as much; he that comes last is commonly best.
> ROBERT BURTON (1577–1640)
> *Anatomy of Melancholy*
> 1621–51

A living civilisation requires learning, but it lies beyond it.
> A.N. WHITEHEAD (1861–1947)
> *Adventures of Ideas*
> 1933

Too much of the animal disfigures the civilised human being, too much culture makes a sick animal.
> CARL GUSTAV JUNG (1875–1961)
> *The Psychology of the Unconscious*

All art is but imitation of nature.
LUCIUS ANNAEUS SENECA (8 BC–65 AD)
Epistles

All the arts are brothers; each one is a light to the others.
VOLTAIRE (1694–1778)
Note to Ode on the Death of the Princess de Bareith

Acting is therefore the lowest of the arts, if it is an art at all.
GEORGE MOORE (1852–1933)
Mummer-Worship

Shall it, then, be unavailing,
All this toil of human culture?
H.W. LONGFELLOW (1807–82)
Birds of Passage: 'Prometheus'

The highbrow arts ... survive morally by becoming, in one way or another, an imitation of death in which their audience can share. To achieve this the artist, in

his role of scapegoat, finds himself testing out his own death and vulnerability for and on himself.

AL ALVAREZ
The Savage God
1971

How thankful we ought to feel that Wordsworth was only a poet and not a musician. Fancy a symphony by Wordsworth! Fancy having to sit it out! And fancy what it would have been if he had written fugues!

SAMUEL BUTLER (1835–1902)
Note Books

Altogether, national hatred is something peculiar. You will always find it strongest and most violent where there is the lowest degree of culture.
J.W. GOETHE (1749–1832)
Conversations with Eckermann

Rules and models destroy genius and art.
WILLIAM HAZLITT (1778–1830)
Sketches and Essays: 'On Taste'

Listen! There never was an artistic period. There never was an Art-loving nation.
JAMES ABBOTT McNEILL WHISTLER (1834–1903)
Ten O'Clock Lecture

I've always thought I'd be particularly good in Romeo – as the nurse.
NOEL COWARD (1899–1973)
quoted in William Marchant's *The Pleasure of His Company*

Though music oft hath such a charm
To make bad good, and good provoke to harm.
WILLIAM SHAKESPEARE (1564–1616)
Measure for Measure

The song of Art is ever
Song of the human soul;
Within herself it never
Is perfectly made whole.
MAY EARLE
Cosmo Venucci

Compared to a novel, a play is simply a string of sentences which are ascribed to people who have not necessarily been described.
JONATHAN MILLER
quoted in *The Listener*, 1978

It is closing time in the gardens of the West and from now on an artist will be judged only by the resonance of his solitude or the quality of his despair.
CYRIL CONNOLLY (1903–74)
in *Horizon*, December 1949

There is an art of reading, as well as an art of thinking, and an art of writing.

ISAAC D'ISRAELI (1766–1848)
The Literary Character of Men of Genius
1795

Everything which makes for sincerity is a further step towards true culture.

LORD SNELL
Men, Movements and Myself

The man that hath no music in himself,
Nor is not moved with concord of sweet sounds,
Is fit for treasons, stratagems, and spoils;
The motions of his spirit are dull as night
And his affections dark as Erebus:
Let no such man be trusted.
 WILLIAM SHAKESPEARE (1564–1616)
 The Merchant of Venice

In other countries, art and literature are left to a lot of
shabby bums living in attics and feeding on booze and
spaghetti, but in America the successful writer or
picture-painter is indistinguishable from any other
decent business man.
 SINCLAIR LEWIS (1885–1951)
 Babbitt
 1922

Art surely should offer suggestions
Of what may refine and refresh,
Not ventilate uncanny questions
About the corruptions of flesh.
 COTSFORD DICK
 The Ways of the World

The more of kindly strength is in the soil,
So much doth evil seed and lack of culture
Mar it the more, and make it run to wildness.
 DANTE ALIGHIERI (1265–1321)
 Purgatory

Reading maketh a full man, conference a ready man,
and writing an exact man.
 FRANCIS BACON (1561–1626)
 Essays: 'Of Studies'

All the arts appertaining to man have a certain
common bond, and are connected by a kind of
relationship.
 MARCUS TULLIUS CICERO (106–43 BC)
 Pro Archia

The secret of life is in art.
 OSCAR WILDE (1854–1900)
 Lecture on the English Renaissance

There are moments when one is more ashamed of what is called culture than anyone can ever be of ignorance.

E.V. LUCAS (1868–1938)
365 Days and One More

You know who the critics are? The men who have failed in literature and in art.

BENJAMIN DISRAELI (1804–81)
Lothair
1870

Was the art of Greece so perfect that its life was also high?

WALTER C. SMITH
Hilda: 'Among the Broken Gods'

The number of pure artists is small. Few souls are so finely tempered as to preserve the delicacy of meditative feeling, untainted by the allurements of accidental suggestion.

DR JOHN BROWN (1810–82)
Horae Subsecivae

Some good, some so-so, and lots plain bad: that's how
a book of poems is made, my friend.
> MARTIAL (40–104)
> *Epigrams*

The men of culture are the true apostles of equality.
> MATTHEW ARNOLD (1822–88)
> *Culture and Anarchy*
> 1869

Imagination means letting the birds in one's head out
of their cages and watching them fly up in the air.
> GERALD BRENAN (1894–)
> *Thoughts in a Dry Season*
> 1978

From women's eyes this doctrine I derive:
They sparkle still the right Promethean fire:
They are the books, the arts, the academes,
That show, contain, and nourish all the world.
> WILLIAM SHAKESPEARE (1564–1616)
> *Love's Labour's Lost*

Artists are a maimed band.
> GEORGE MACDONALD (1824–1905)
> *Brother Artist*

Our idea of a cultured person is a person who doesn't want to live in a community of cultured persons.
> E.B. WHITE
> *Every Day is Saturday*

Culture is far more dangerous than Philistinism, because it is more intelligent and more pliant. It has a specious air of being on the side of the artist.
> CLIVE BELL (1881–1962)
> *Art*
> 1914

Writing, Madam, 's a mechanic part of wit! A gentleman should never go beyond a song or a billet.
> SIR GEORGE ETHEREGE (1635–91)
> *The Man of Mode*
> 1676

I think it is time there was an innovation to protect the author and the actor and the public from the vagaries of the director. Given a good play and a good

team and a decent set you could put a blue-arsed baboon in the stalls and get what is known as a production.

PETER O'TOOLE
quoted in *Playboy*, 1965

'May the Devil fly away with the fine arts!' exclaimed —— in my hearing, one of our most distinguished public men.

THOMAS CARLYLE (1795–1881)
Latter-day Pamphlets, no. 6: 'Parliaments'
1850

We'll cry both arts and learning down,
And hey! then up go we!
FRANCIS QUARLES (1592–1644)
The Shepherd's Oracles

In framing artist, art hath thus decreed,
To make some good, but others to succeed.
WILLIAM SHAKESPEARE (1564–1616)
Pericles, Prince of Tyre

There is no culture in the hearts of people unless the very utensils in the kitchen are beautiful.
WILLIAM BUTLER YEATS (1865–1939)
quoted in *Ladies' Home Journal*, June 1942

No arts; no letters; no society; and which is worst of all, continual fear and danger of violent death; and the life of man, solitary, poor, nasty, brutish, and short.
THOMAS HOBBES (1588–1679)
Leviathan
1651

Let me die to the sounds of delicious music.
ERNEST MIRABEAU
said to be his last words

Art is meant to disturb. Science reassures.
GEORGES BRAQUE (1882–1963)
Pensees sur l'Art

There's sure no passion in the human soul,
But finds its food in music.
GEORGE LILLO (1693–1739)
The Fatal Curiosity
1736

So have I loitered my life away, reading books,
looking at pictures, going to plays, hearing, thinking,
writing on what pleased me best. I have wanted only
one thing to make me happy, but wanting that have
wanted everything.
WILLIAM HAZLITT (1778–1830)
English Literature

Elected silence, sing to me,
And beat up on my whorled ear,
Pipe me to pastures still and be
The music that I care to hear.
GERARD MANLEY HOPKINS (1844–89)
The Habit of Perfection

All art constantly aspires towards the condition of music.
WALTER PATER (1839–94)
The Renaissance

The whole world without art and dress
Would be but one great wilderness.
SAMUEL BUTLER (1612–80)
Miscellaneous Thoughts

The failure to touch the common mind, upon which our cultivated people appear to pride themselves, is not, as they imagine, a sign of their superiority, but rather a clear proof of the inadequacy of their ideal. Culture invariably dies, unless refreshed by the common intelligence, and before it dies it very frequently becomes corrupt.
J.A. SPENDER
The Comments of Bagshot

As the arts advance towards their perfection, the science of criticism advances with equal pace.

EDMUND BURKE (1729–97)
On the Sublime and Beautiful
1756

I think that a knowledge of Greek thought and life, and of the arts in which the Greeks expressed their thought and sentiment, is essential to high culture. A man may know everything else, but without this knowledge he remains ignorant of the best intellectual and moral achievements of his own race.

CHARLES ELIOT NORTON (1827–1908)
Letter to F. A. Tupper
1885

It is art that *makes* life, makes interest, makes importance, for our consideration and application of those things, and I know of no substitute whatever for the force and beauty of its process.

HENRY JAMES (1843–1916)
letter to H.G. Wells
10 July 1915

He that revels in a well-chosen library, has innumerable dishes, and all of admirable flavour.
> WILLIAM GODWIN (1756–1836)
> *The Enquirer*

I never indulge in poetics
Unless I am down with rheumatics
> QUINTUS ENNIUS (239–169 BC)
> *Fragment of a Satire*
> quoted by Priscianus

Human salvation lies in the hands of the creatively maladjusted.
> MARTIN LUTHER KING, JUN.
> *Strength to Love*
> 1963

Hardly anyone knows that the secret of beautiful work lies to a great extent in truth and sincere sentiment.
> VINCENT VAN GOGH (1853–90)
> *An Autobiography of Vincent Van Gogh*

A man that has a taste of music, painting, or architecture, is like one that has another sense, when compared with such as have no relish of those arts.

> JOSEPH ADDISON (1672–1719)
> in *The Spectator*
> issue 97, 16 June 1711

Books are a world in themselves, it is true; but they are not the only world. The world itself is a volume larger than all the libraries in it.

> WILLIAM HAZLITT (1778–1830)
> *On the Conversation of Authors*

If a play does anything – either tragically or comically, satirically or farcically – to explain to me why I am alive, it is a good play. If it seems unaware that such questions exist, I tend to suspect that it is a bad one.

> KENNETH TYNAN (1927–80)
> *Tynan Right and Left*
> 1967

The artist is the son of his time; but pity him if he is its pupil or even its favourite.

> JOHANN CHRISTOPH FRIEDRICH VON SCHILLER
> (1759–1805)
> *On Naive and Reflective Poetry*
> 1795

So I do believe ... that works of genius are the first things in this world.

> JOHN KEATS (1795–1821)
> *Letters*

A work that aspires, however humbly, to the condition of art should carry its justification in every line.

> JOSEPH CONRAD (1857–1924)
> *The Nigger of the Narcissus*
> 1897

The books we think we ought to read are poky, dull
 and dry,
The books that we would like to read we are
 ashamed to buy;
The books that people talk about we never can
 recall;

And the books that people give us, oh, they're the
worst of all.
CAROLYN WELLS (1870–1942)
On Books

The Arts are sisters; Languages are close kindred;
Sciences are fellow-workmen.
SIR ARTHUR HELPS (1813–75)
Friends in Council

When a thing needs no imaginative effort to get hold
of it, it's not a work of art.
WILLIAM J. LOCKE

The learned understand the theory of art, the
unlearned the pleasure.
QUINTILIAN (35–95)
De Institutione Oratoria

Honour nourishes the arts, and all are kindled to
study by love of glory.
MARCUS TULLIUS CICERO (106–43 BC)
Tusculanae Disputationes

Woe be to him that reads but one book.
> GEORGE HERBERT (1593–1633)
> *Jacula Prudentum*
> 1651

A great library contains the diary of the human race.
> REVD GEORGE DAWSON
> on opening Birmingham Free Library, 1866

Poussin said quite correctly that 'the goal of art is delectation.' He did not say that this delectation should be the goal of the artist who must always submit solely to the demands of the work to be done.
> IGOR STRAVINSKY (1882–1971)
> *Poetics of Music*

I love to lose myself in other men's minds. When I am not walking, I am reading; I cannot sit and think. Books think for me.
> CHARLES LAMB (1775–1834)
> *Last Essays of Elia*
> 1833

We are all heirs to the loveliness of the visible world, but only by process of art can we be inducted into possession of this large estate.

C.E. MONTAGUE (1867–1928)
A Writer's Notes on his Trade

Culture is an instrument wielded by professors to manufacture professors, who when their turn comes will manufacture professors.

SIMONE WEIL (1909–43)
The Need for Roots

Practice and thought might gradually forge many an art.

VIRGIL (70–19 BC)
Georgics

'Ugliness,' he would always say, 'is but skin deep. The business of Art is to reveal the beauty underlying all things.'

JEROME K. JEROME (1859–1931)
The Passing of the Third Floor Back
1907

Affect not as some do that bookish ambition to be stored with books and have well-furnished libraries, yet keep their heads empty of knowledge; to desire to have many books, and never to use them, is like a child that will have a candle burning by him all the while he is sleeping.

HENRY PEACHAM (?1576–?1643)
The Compleat Gentleman
1622

It's idle to play the lyre for an ass.

ST JEROME (342–420)
Letters

Art hath an enemy called Ignorance.

BEN JONSON (1572–1637)
Every Man Out of His Humour
1599

Poets that lasting marble seek
Must come in Latin or in Greek.

EDMUND WALLER (1606–87)
Of English Verse
1668

We prefer a gipsy by Reynolds to his Majesty's head on a signpost.

> LORD MACAULAY (1800–59)
> Moore's *Life of Lord Byron*, 1830

In a beautiful city an art gallery would be superfluous. In an ugly one it is a narcotic.

> HOLBROOK JACKSON
> *Platitudes for the Making*

Criticism is easy, art is difficult.

> PHILIPPE NERICAULT (1680–1754)
> *Le Glorieux*
> 1732

Real culture lives by sympathies and admirations, not by dislikes and disdains; under all misleading wrappings it pounces unerringly upon the human core.

> WILLIAM JAMES (1842–1910)
> *Memories and Studies*

When I want to read a novel I write one.

> BENJAMIN DISRAELI (1804–81)
> attributed

High is our calling, Friend! Creative Art
Demands the service of a mind and heart.
> WILLIAM WORDSWORTH (1770–1850)
> *Miscellaneous Sonnets*

This great society is going smash;
They cannot fool us with how fast they go,
How much they cost each other and the gods!
A culture is no better than its woods.
> W.H. AUDEN (1907–73)
> *Winds*

An artist is someone who produces things that people don't need to have but that he – for some reason – thinks it would be a good idea to give them.
> ANDY WARHOL (1928–1987)
> *From A to B and Back Again*

Art is one of the few things, apart from love and friendship, to be worth caring about. No matter how it is generally neglected and debased, it is a way of securing some sense of continuity in the uneven and perilous business of human life.
> BRIAN ALDISS (1925–)
> in *The Guardian*, 1971

Works of art can wait: indeed, they do nothing but that and do it passionately.
RAINER MARIA RILKE (1875–1926)
Letters

A best-seller is the gilded tomb of a mediocre talent.
LOGAN PEARSALL SMITH (1865–1946)
Afterthoughts: 'Art and Letters'
1931

A good novel tells us the truth about its hero; but a bad novel tells us the truth about its author.
G.K. CHESTERTON (1874–1936)
Heretics

Culture is on the horns of this dilemma; if profound and noble, it must remain rare; if common it must become mean.
GEORGE SANTAYANA (1863–1952)
The Life of Reason
1906

The young ladies, eager for the delights of music and dancing, now entered, followed by Coil, the piper, dressed in the native garb, with cheeks seemingly

ready blown for the occasion. After a little strutting and puffing, the pipes were fairly set agoing in Coil's most spirited manner. But vain would be the attempt to describe Lady Juliana's horror and amazement at the hideous sounds that for the first time assailed her ear. Tearing herself from the grasp of the old gentleman, who was just setting off in the reel, she flew shrieking to her husband, and threw herself trembling into his arms, while he called loudly to the self-delighted Coil to stop.

'What's the matter – what's the matter?' cried the whole family, gathering around.

'Matter!' repeated Douglas furiously, 'you have frightened lady Juliana to death with your infernal music. What did you mean,' turning fiercely to the astonished piper, 'by blowing that confounded bladder?'

SUSAN FERRIER (1782–1854)
Marriage
1818

Books cannot always please, however good:
Minds are not ever craving for their food.
GEORGE CRABBE (1754–1832)
The Borough

A good critic is one who narrates the adventures of his mind among masterpieces.
> ANATOLE FRANCE (1844–1924)
> *La Vie Litteraire*

The rest may reason and welcome; 'tis we musicians know.
> ROBERT BROWNING 1812–89)
> *Abt Vogler*

Due attention to the inside of books, and due contempt for the outside, is the proper relation between a man of sense and his books.
> EARL OF CHESTERFIELD (1694–1773)
> *Letters*
> 1749

Poetry is not the proper antithesis to prose, but to science. Poetry is opposed to science, and prose to metre.
> SAMUEL TAYLOR COLERIDGE (1772–1834)
> *Lectures and Notes of 1818*

If the writer be a fellow that hath either epigrammed you, or hath had a flirt at your mistress, or hath brought either your feather, or your red beard, or your

little legs, etc., on the stage, you shall disgrace him worse than by tossing him in a blanket, or giving him the bastinado in a tavern, if, in the middle of his play (be it pastoral or comedy, moral or tragedy) you rise with a screwed and discontented face from your stool to be gone. No matter whether the scenes be good or no; the better they are, the worse do you distaste them.

THOMAS DEKKER (1570–1641)
The Guls Hornebooke
1609

Such and so various are the tastes of men.

MARK AKENSIDE (1721–70)
The Pleasures of the Imagination

Mr H...rr...n, one of the commissioners of the Revenue in Ireland, being one night in the pit, at the Playhouse in Dublin, Monoca Gall, the orange girl, famous for her wit and her assurance, striding over his back, he popp'd his hands under her petticoats: Nay, Mr Commissioner, said she, you'll find no goods there but what have been fairly entered.

ANON
Joe Miller's Jests
1739

Novel: a small tale, generally of love.
SAMUEL JOHNSON (1709–84)
A Dictionary of the English Language
1755

A poet without love were a physical and metaphysical impossibility.
THOMAS CARLYLE (1795–1881)
Critical and Miscellaneous Essays

From the poetry of Lord Byron they drew a system of ethics, compounded of misanthropy and voluptuousness, in which the two great commandments were, to hate your neighbour, and to love your neighbour's wife.
THOMAS BABINGTON MACAULEY (1800–59)
Literary Essays

She prefers the Venus de Medicine to any other statue she knows about.
BENJAMIN PENHALLOW SHILLABER (1814–90)
The Life and Sayings of Mrs Partington
1854

Who says that fictions only and false hair
Become a verse? Is there in truth no beauty?
Is all good structure in a winding stair?
GEORGE HERBERT (1593–1633)
Temple

My books are water: those of the great geniuses are
wine. Everybody drinks water.
MARK TWAIN (1835–1910)
Mark Twain's Notebook
1935

I wish to say one word about Michael Angelo
Buonarotti – I used to worship the mighty genius of
Michael Angelo – that man who was great in poetry,
painting, sculpture, architecture – great in everything
he undertook. But I do not want Michael Angelo for
breakfast, for luncheon, for tea, for supper, for
between meals. I like a change occasionally ... I never
felt so fervently thankful, so soothed, so tranquil, so
filled with a blessed sense of peace, as I did yesterday
when I learnt that Michael Angelo was dead.
MARK TWAIN (1835–1910)
The Innocents Abroad
1869

One half of the world cannot understand the pleasures of the other.

>JANE AUSTEN (1775–1817)
>*Emma*

Never meddle with play-actors, for they are a favoured race.

>MIGUEL CERVANTES (1547–1616)
>*Don Quixote*

Literature flourishes best when it is half a trade and half an art.

>W.R. INGE (1860–1954)
>*The Victorian Age*

Art comes to you proposing frankly to give nothing but the highest quality to your moments as they pass, and simply for those moments' sake.

>WALTER PATER (1839–94)
>*The Renaissance*

Carrie is not above putting a button on a shirt, mending a pillowcase, or practising the 'Sylvia Gavotte' on our new cottage piano (on the three

years' system), manufactured by W. Bildon (in small letters), from Collard and Collard (in very large letters).

GEORGE AND WEEDON GROSSMITH (1847–1912, 1854–1919)
The Diary of a Nobody
1892

At the end of the first act, as the green curtain dropped, to prepare for the dance, they imagined that the Opera was done, and Mr Branghton expressed great indignation that he had been tricked out of his money with so little trouble. 'Now if any Englishman was to do such an impudent thing as this,' said he, 'why he'd be pelted; but here, one of these outlandish gentry may do just what he pleases, and come on, and

squeak out a song or two, and then pocket your money without further ceremony.'
> FANNY BURNEY (1752–1840)
> *Evalina*
> 1778

It is a pretty poem, Mr Pope, but you must not call it Homer.
> RICHARD BENTLEY (1662–1742)
> of Alexander Pope's *Iliad*, quoted in Johnson's *Life of Pope*

I saw Hamlet, Prince of Denmark, played; but now the old plays begin to disgust this refined age.
> JOHN EVELYN (1620–1706)
> *Diary*
> 1661

He sat down, tugging at a white paper package in the tail pocket of his coat.

'Cherries,' he said, nodding and smiling. 'There is nothing like cherries for producing free saliva after trombone playing, especially after Grieg's *Ich Liebe Dich*. Those sustained blasts in *liebe* make my throat as

dry as a railway tunnel. Have some?' He shook the bag at me.

> KATHERINE MANSFIELD (1888–1923)
> *In a German Pension*
> 1911

Music hath charms to soothe a savage breast,
To soften rocks, or bend a knotted oak.

> WILLIAM CONGREVE (1670–1729)
> *The Mourning Bride*

The condition of an author is much like that of a strumpet, both exposing our reputations to supply our necessities, till at last we contract such ill habits, through our practices, that we are equally troubled with an itch to be always doing: and if the reason be requir'd, why we betake ourselves to so scandalous a profession, as whoring and pamphleteering, the same executive answer will serve us both, viz, that the unhappy circumstances of a narrow fortune, hath forc'd us to do that, for our substance, which we are much ashamed of.

> EDWARD WARD (1667–1731)
> *A Trip to Jamaica*
> 1698

If Bach wriggles, Wagner writhes.
> SAMUEL BUTLER (1835–1902)
> *Notebooks*

It is the glory and the good of Art
That Art remains the one way possible
Of speaking truth, to minds like mine at least.
> ROBERT BROWNING (1812–89)
> *Ring and the Book*

Swans sing before they die – 'twere no bad thing
Did certain persons die before they sing.
> SAMUEL TAYLOR COLERIDGE (1772–1834)
> *Epigram on a Volunteer Singer*

Blest be the art that can immortalise.
> WILLIAM COWPER (1731–1800)
> *On the Receipt of My Mother's Picture*

Art is a jealous mistress.
> RALPH WALDO EMERSON (1806–82)
> *Conduct of Life*

As writers become more numerous, it is natural for readers to become more indolent.
> OLIVER GOLDSMITH (1728–74)
> *The Bee*

So have I loitered my life away, reading books, looking at pictures, going to plays, hearing, thinking, writing on what pleased me best. I have wanted only one thing to make me happy, but wanting that have wanted everything.
> WILLIAM HAZLITT (1778–1830)
> *My First Acquaintance With Poets*